THE COLORING BOOK OF
LATINX ARTISTS

RITA GONZALEZ

LINE DRAWINGS
PAULA KINSEL

MERRELL
LONDON · NEW YORK

in association with

VILCƎK
FOUNDATION

INTRODUCTION

The term *Latinx art* is used to describe works created by artists of Latin American birth or descent who live in the United States. It encompasses a diverse range of artistic practices, from geometric abstraction to figurative and conceptual approaches. This range is represented in my selection for the coloring book. The term *Latinx* emerged in the early twenty-first century. An identifier, it was used in place of *Latino* or *Latina* when referring to people of Latin American origin or heritage, replacing the masculine *-o* or feminine *-a* with *-x* so as to be gender-neutral and inclusive. The term *Latinx* should be considered fluid, for the multiplicity it represents.

The impact of Latinx populations on everything from urban design to self-ornamentation and cultural fusions has been tremendously underestimated and underrecognized. Latinx civil rights movements share aesthetic and community-based strategies that have been propelled by strong print (and more recently, digital) cultures. Examples are evident in the strong visual cultures that link Puerto Rican and Chicanx communities—from the graphic design of political posters and flyers to provocative public murals and stencil graffiti. Print culture also emboldened Latinx artists to respond to US government interventions in Central America. In this sense, Latinx art is a strategic means to identify affinities, whether those are shared historical legacies or similar political stances and aesthetic modes.

This gathering of artists, which spans a number of generations, is a celebration of many things that are key to Latinx art, in particular a powerful balancing of aspects of everyday working- and middle-class life with innovations in cultural translation. Many of the artists represented in this selection also bring together historical references to art, design, and self-fashioning across time periods and geographies.

This playful mixture of influences binds cultural references into the everyday. Patrick Martinez draws primarily from vernacular culture—bakeries, custom cars, boxlike urban architecture—and transforms

these recognizable forms into vivid, layered paintings. Ana Serrano's sculptures and paintings relay how expressions of personality are inscribed by immigrant communities onto the built environment. Michael Menchaca overlays graphic and gaming design with the tradition of casta painting, producing a playful but menacing combination of references. Sandy Rodriguez's process is deeply rooted in historical research to the extent that even the chemical makeup of color itself becomes subject matter. Referencing the spaces of visual display, Gala Porras-Kim's work challenges us to rethink the ethics of collection, in particular how proprietary claims on materials and knowledge are made by so-called neutral museums.

Patssi Valdez has long been interested in abundance and excess in her highly stylized depictions of figures and devotional objects. Self-fashioning and mythologizing are also critical to the art of Marcel Alcalá and Felipe Baeza. Ms. Yellow (Nuria Ortiz) overlays and overlaps Mesoamerican iconography with contemporary stylizing of self. Similarly, Jaime Muñoz considers culture as fluid and responsive, as evidenced in his attention to the innovations and cross-pollinations of everyday customization (of cars, windows, etc.) that transpose the ancient and the futuristic. Eamon Ore-Giron and Carlos Rosales-Silva push against the accepted readings of modernism as being rooted solely in European innovation with their use of design motifs and symbology from the ancient Americas. Likewise, Carolyn Castaño politicizes design motifs drawn from depictions of the tropical Americas to foreground underrepresented feminist histories.

These allusions to graphic design, video games, casta paintings, poster art, custom car culture, science fiction, baroque art, vernacular architecture, Tropicália, museum display, and queer self-fashioning show the depth and range of Latinx art, and its ability to transform itself, without loss of density or dynamics, onto the pages of an accessible coloring book.

Rita Gonzalez

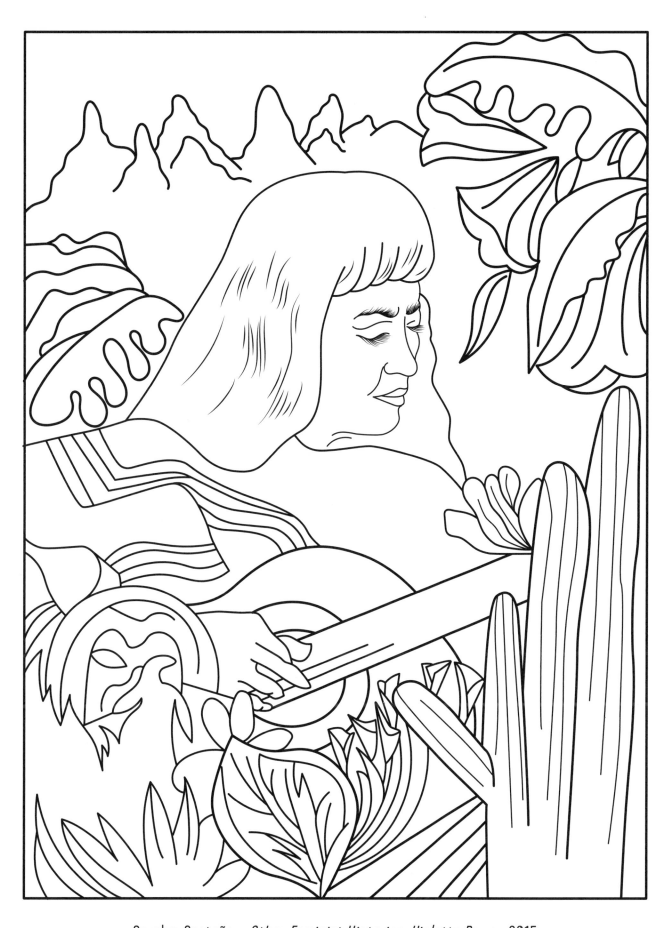

Carolyn Castaño · *Other Feminist Histories: Violetta Parra* · 2015

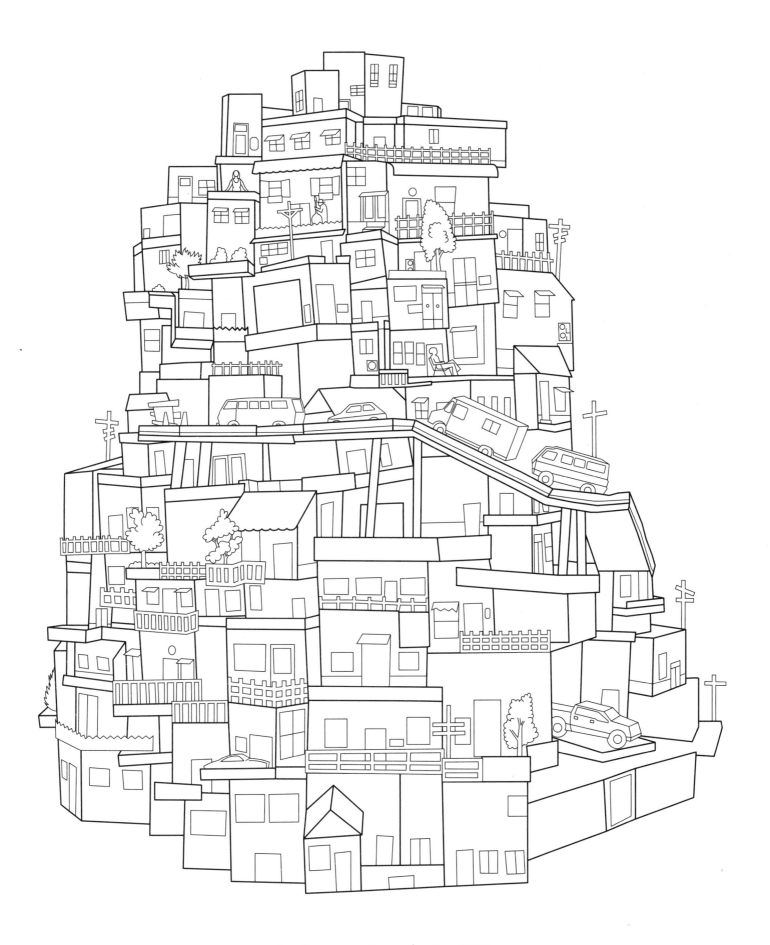

Ana Serrano · *Cartonlandia* · 2008

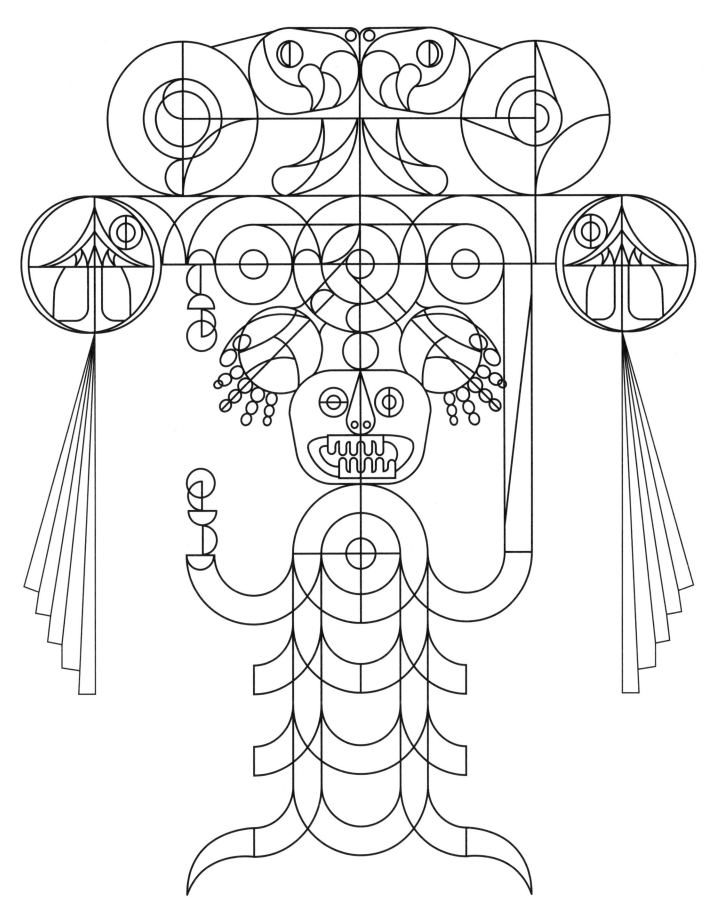

Eamon Ore-Giron · *Talking Shit with Coatlicue* · 2017

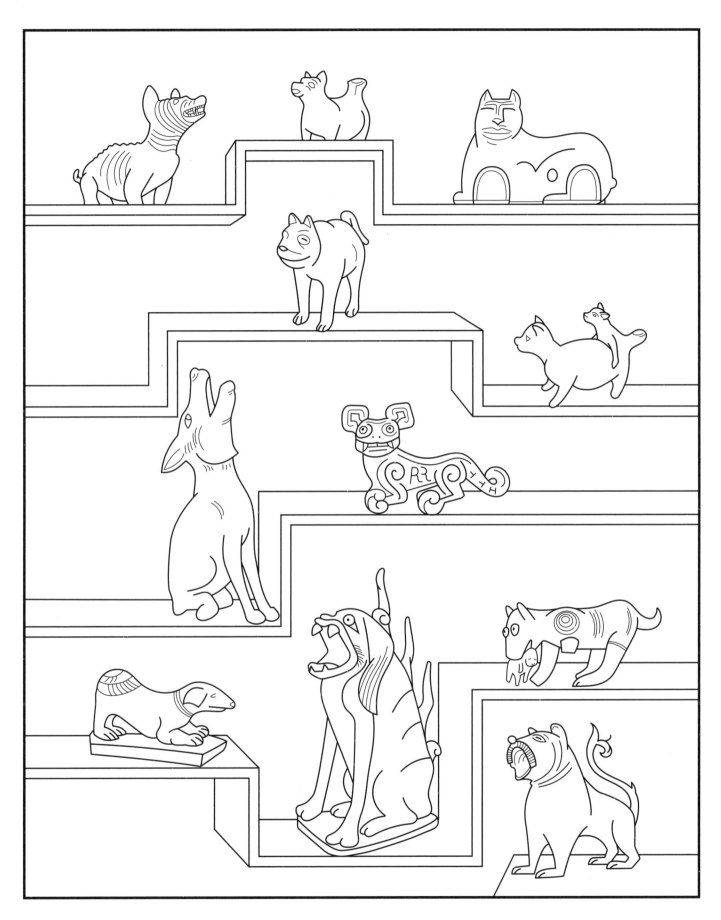

Gala Porras-Kim · *13 International Dogs* · 2019

Jaime Muñoz · *Hands for Hire* · 2018

Marcel Alcalá · *Amor Eterno* · 2019

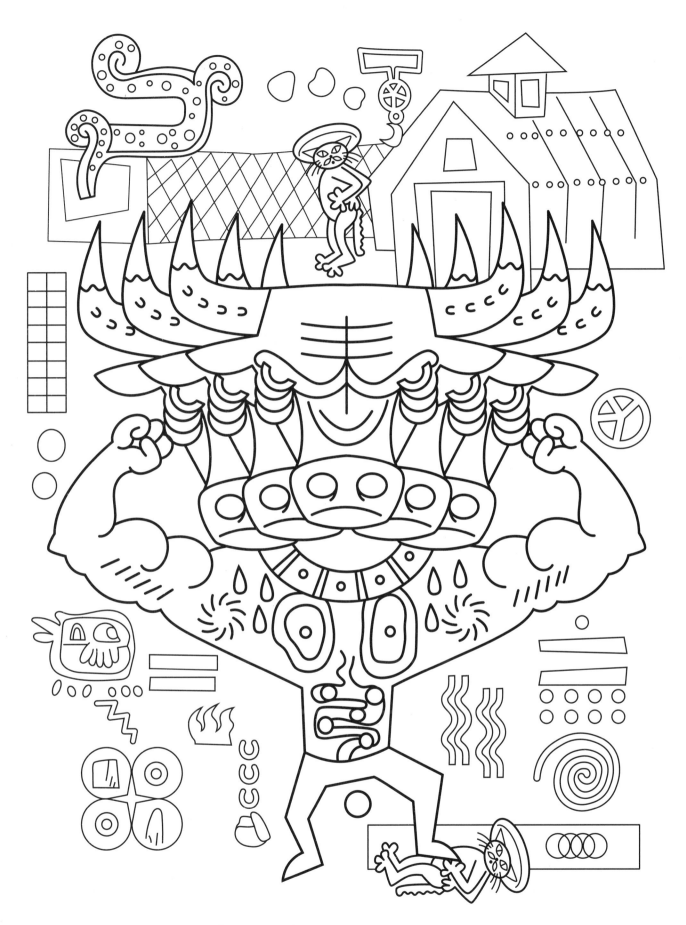

Michael Menchaca · *Toro Lo Que Quieras Es Tuyo* · 2013

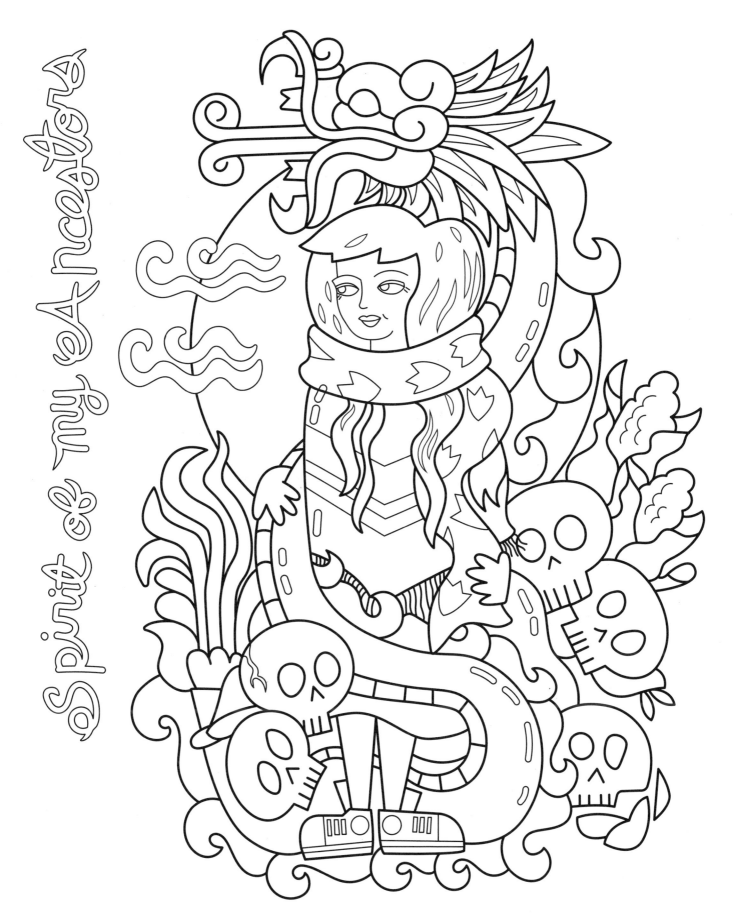

Ms. Yellow (Nuria Ortiz) • *Spirit of my Ancestors* • 2018

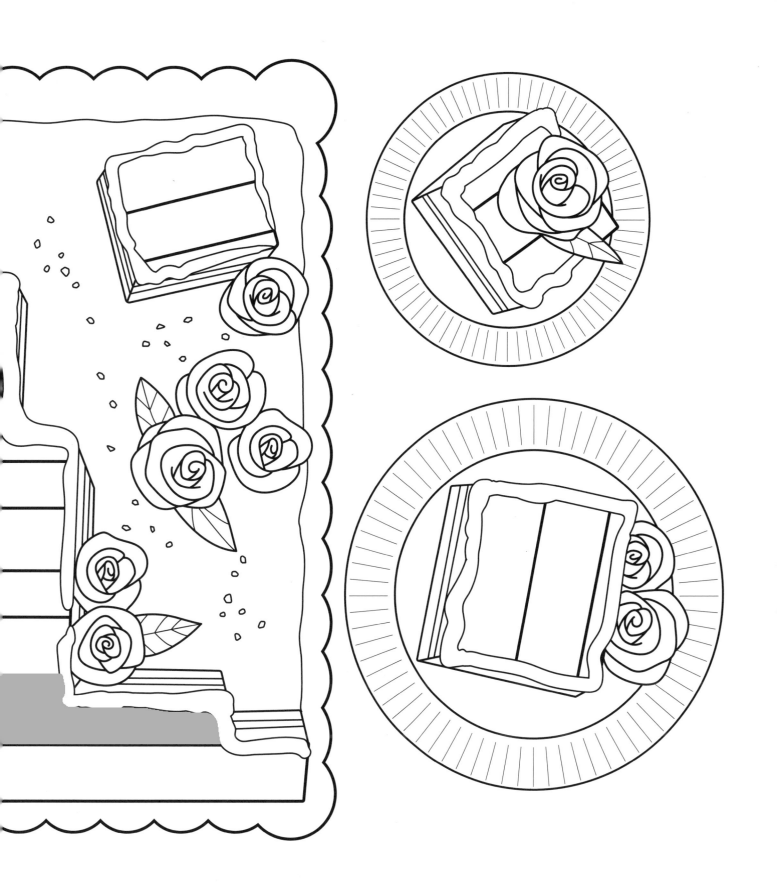

Patrick Martinez · *America's Pie* · 2018

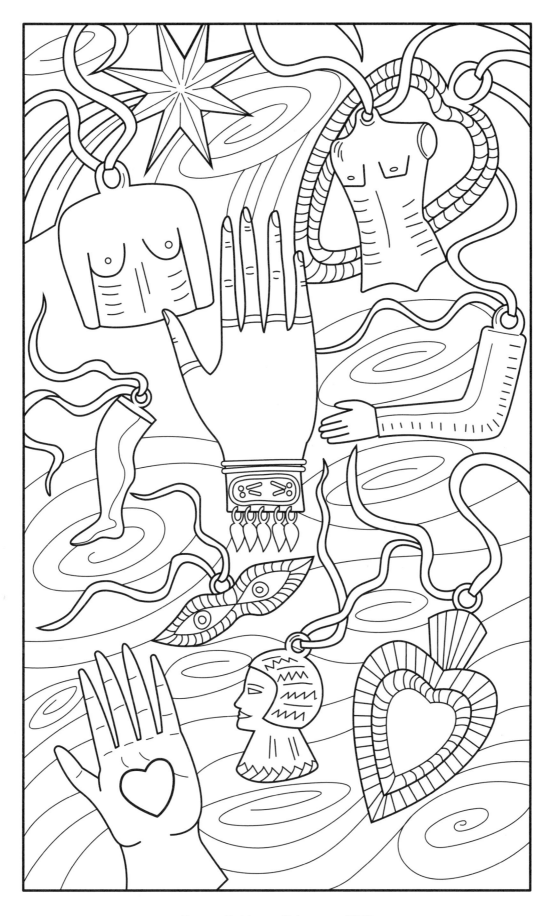

Patssi Valdez · *Milagros* · 2016

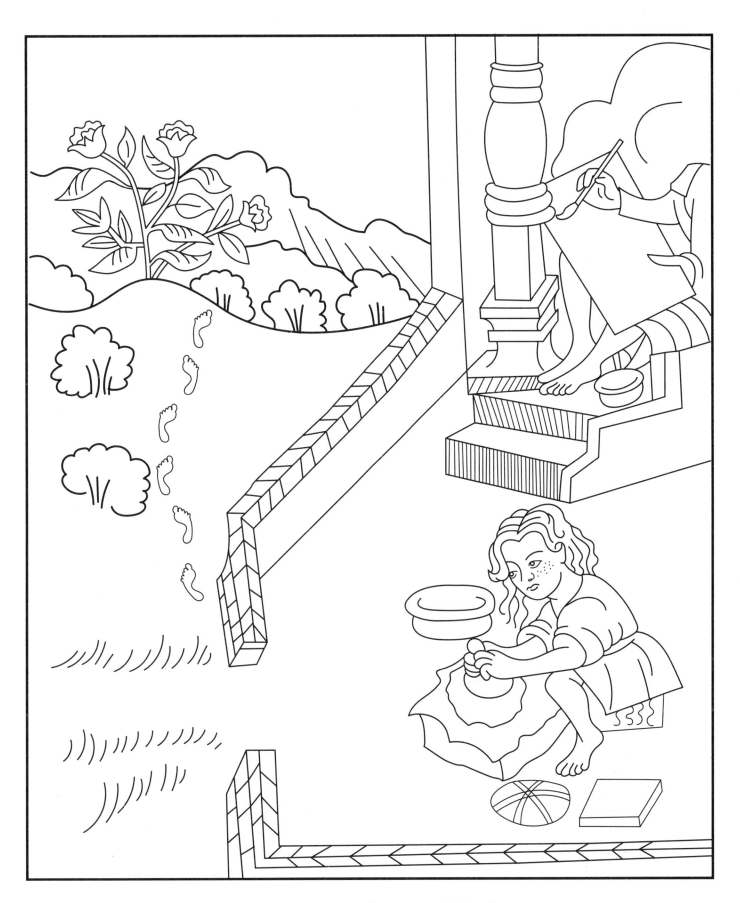

Sandy Rodriguez • "Processing Quiltic,"
detail from *Mapa de la Región Fronteriza de Alta y Baja Califas* • 2017

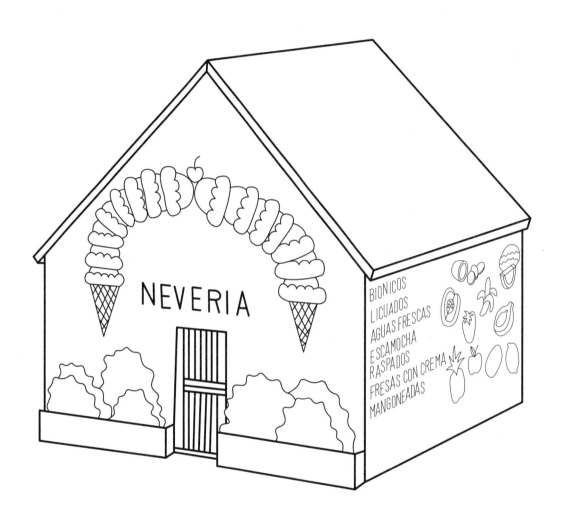

Ana Serrano · *Neveria* · 2012

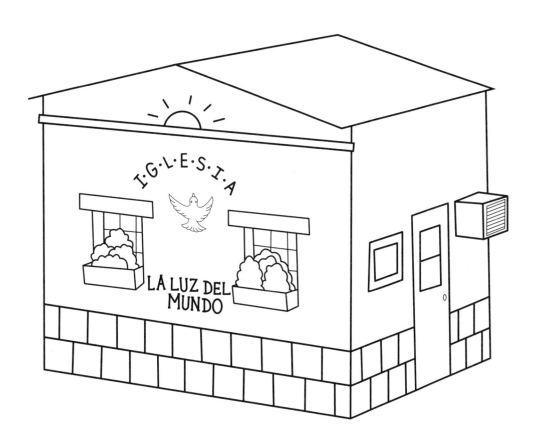

Ana Serrano · *Iglesia La Luz del Mundo* · 2012

Carolyn Castaño
Tropical Geometries: Ruana Interruption (Red and Gold) · 2017

Carlos Rosales-Silva · *Yeyi Coatl* · 2019

Carlos Rosales-Silva · *Chupando Tamarindo* · 2019

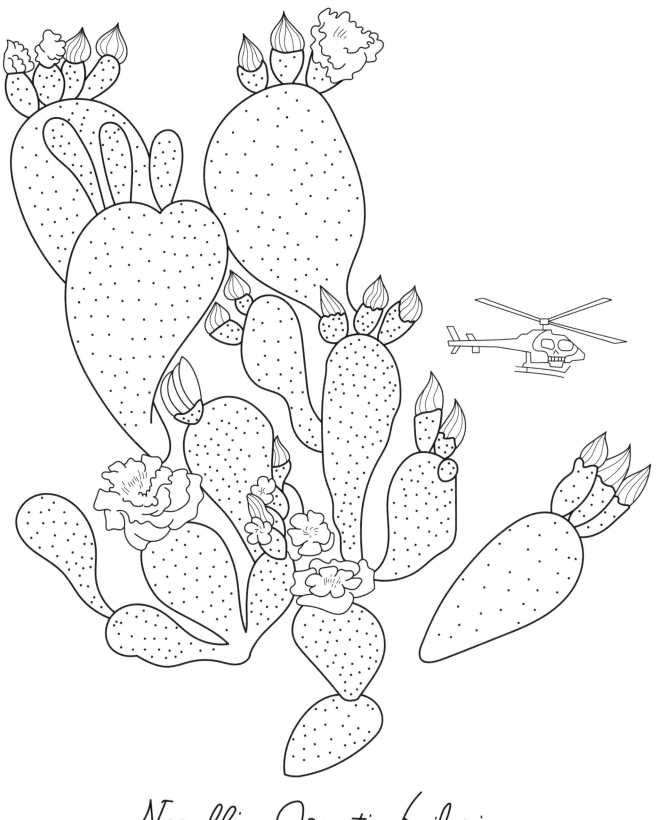

Nopalli ~ Opuntia basilaris

Sandy Rodriguez
Nopal-Opuntia basilaris from the Codex Rodriguez-Mondragón · 2017

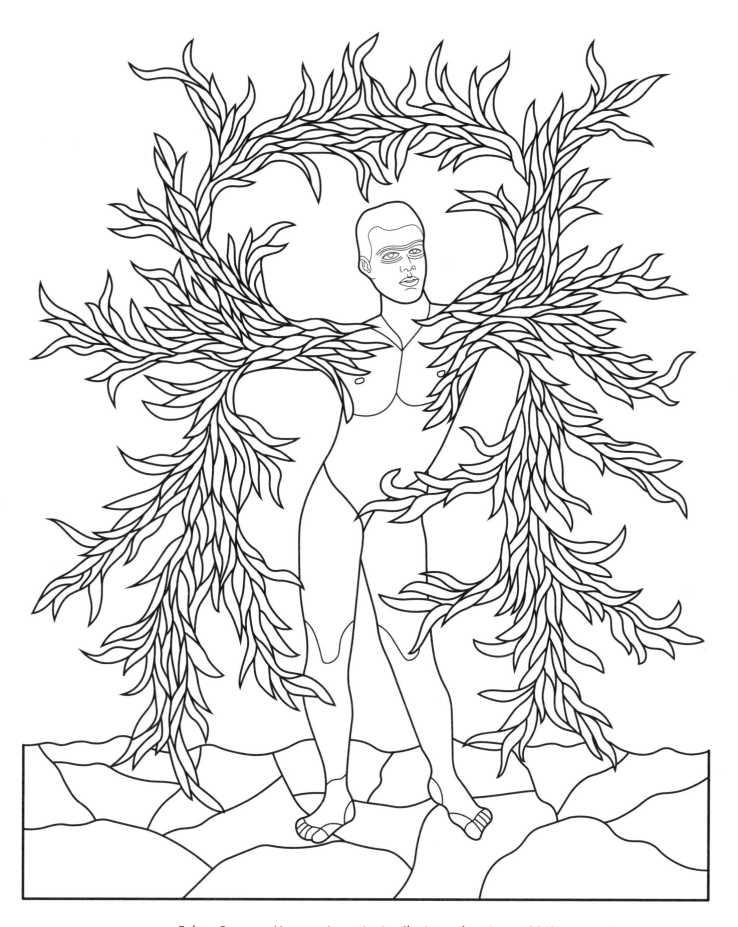

Felipe Baeza · *Moving through the flesh to elsewhere* · 2019

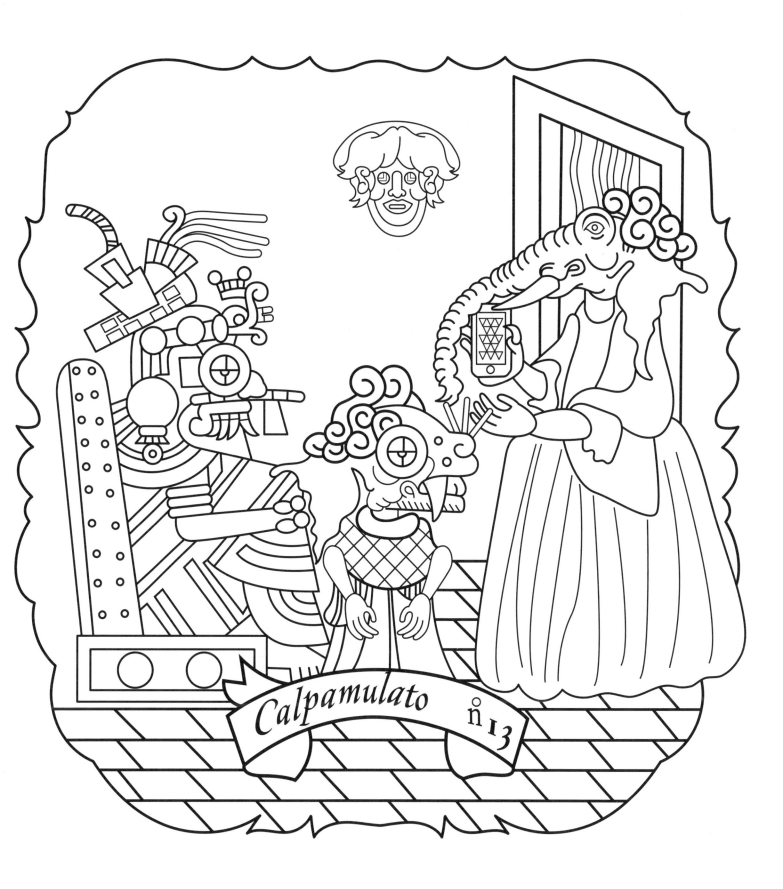

Michael Menchaca
Calpamulato No. 13 from La Raza Cósmica 20XX · 2019

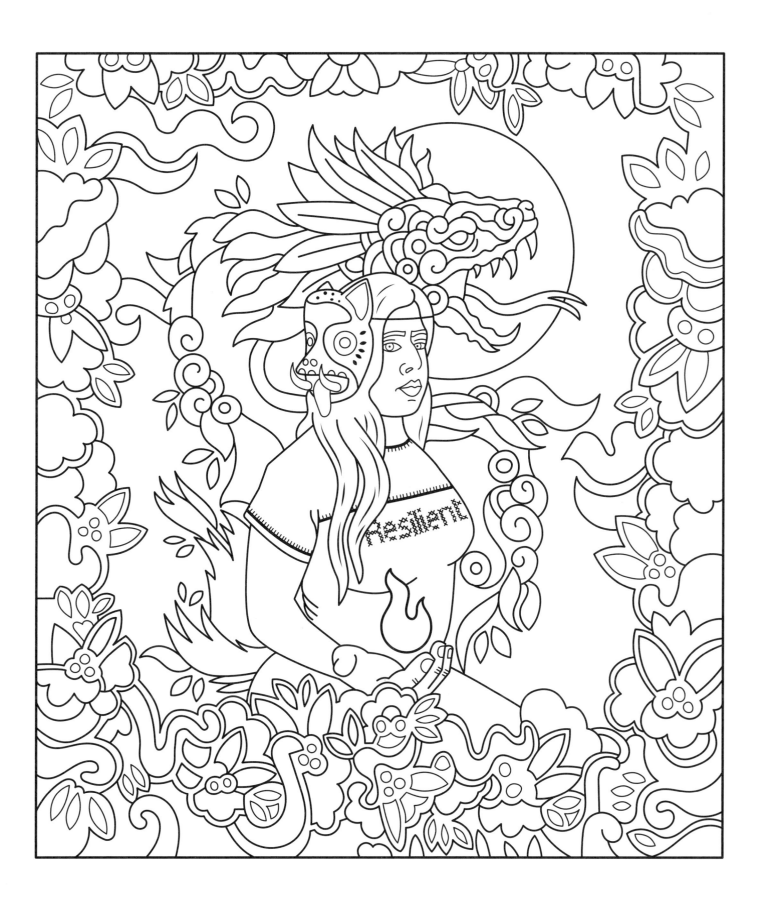

Ms. Yellow (Nuria Ortiz) · *Resilient* · 2021

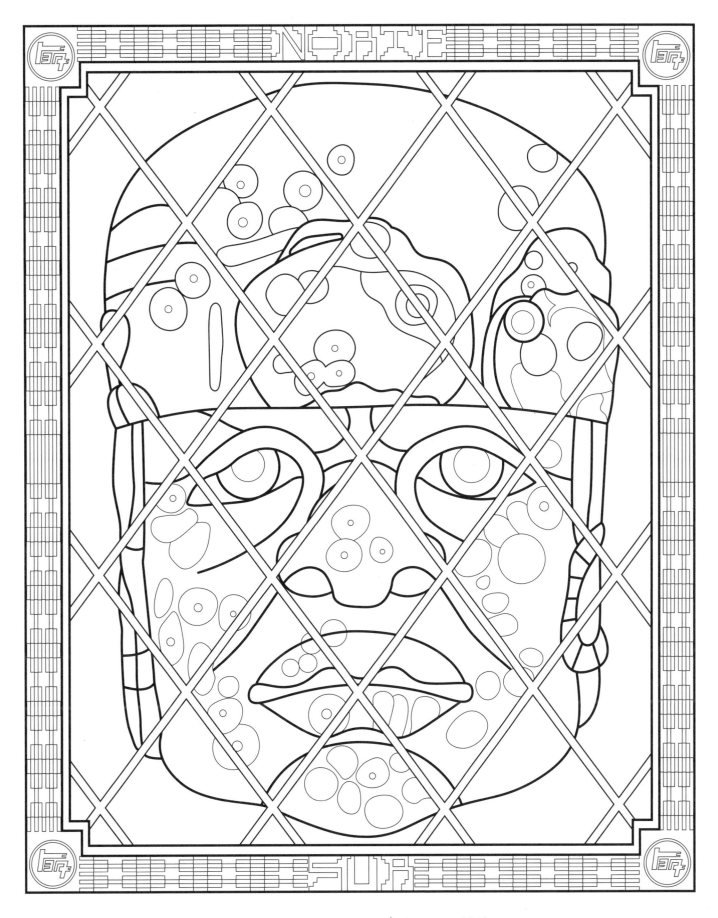

Jaime Muñoz · *Impossible Dreams* · 2018

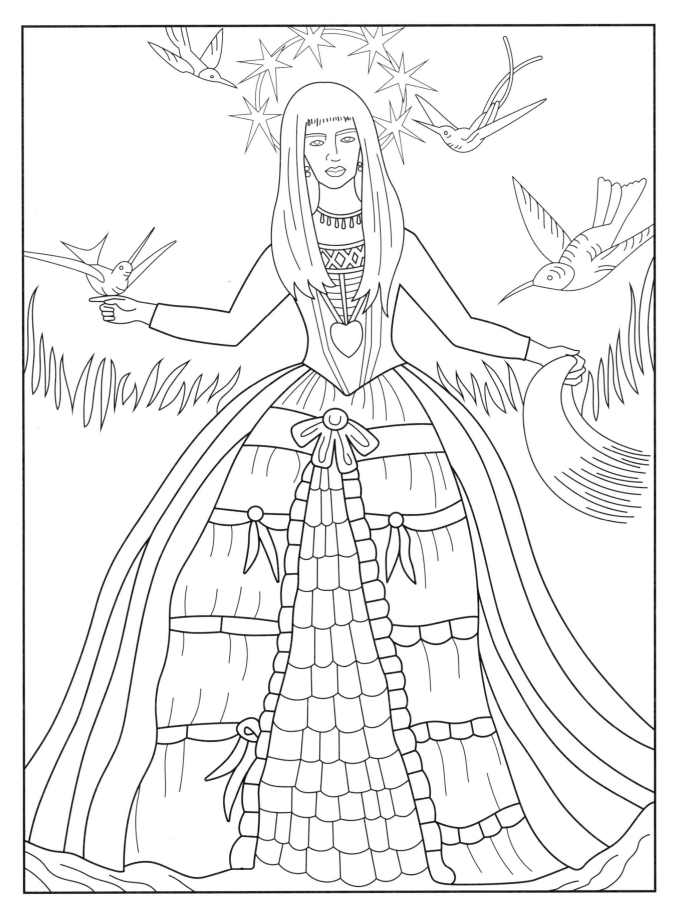

Patssi Valdez · *The Hummingbird Queen* · 2017

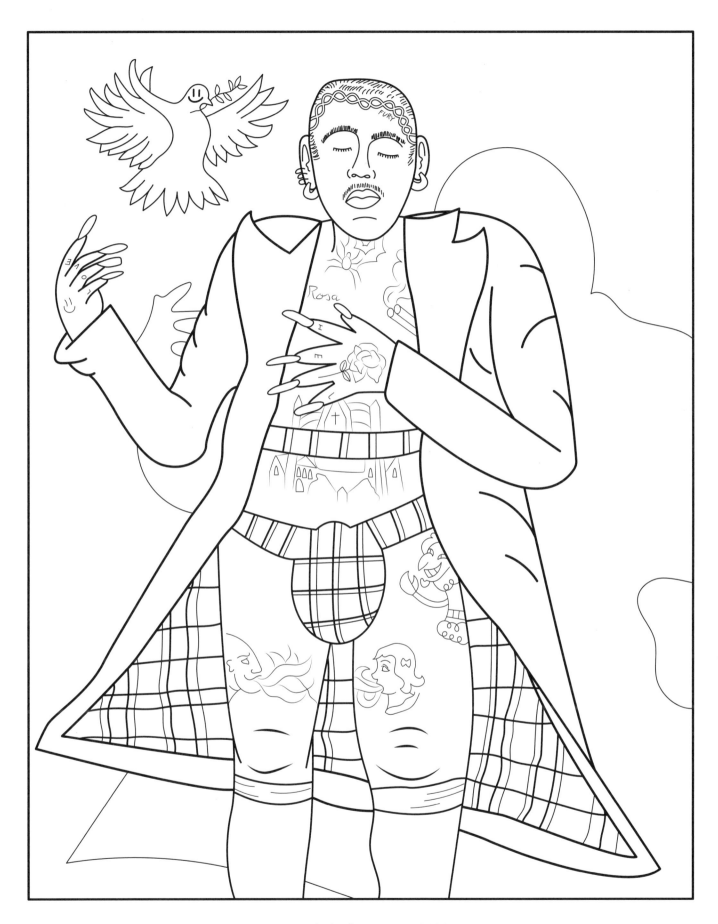

Marcel Alcalá · *Lucy* · 2020

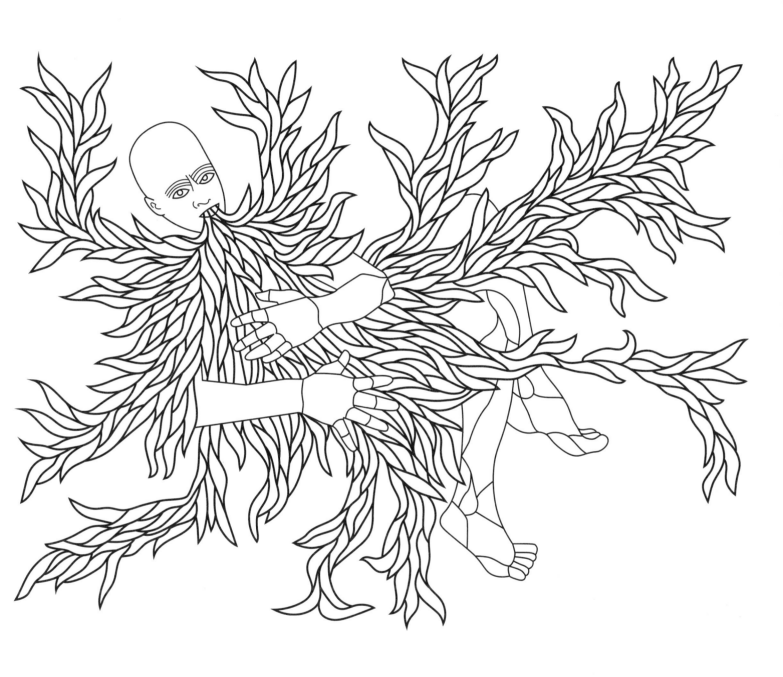

Felipe Baeza · *Tanto refugio como advertencia a la vez* · 2019

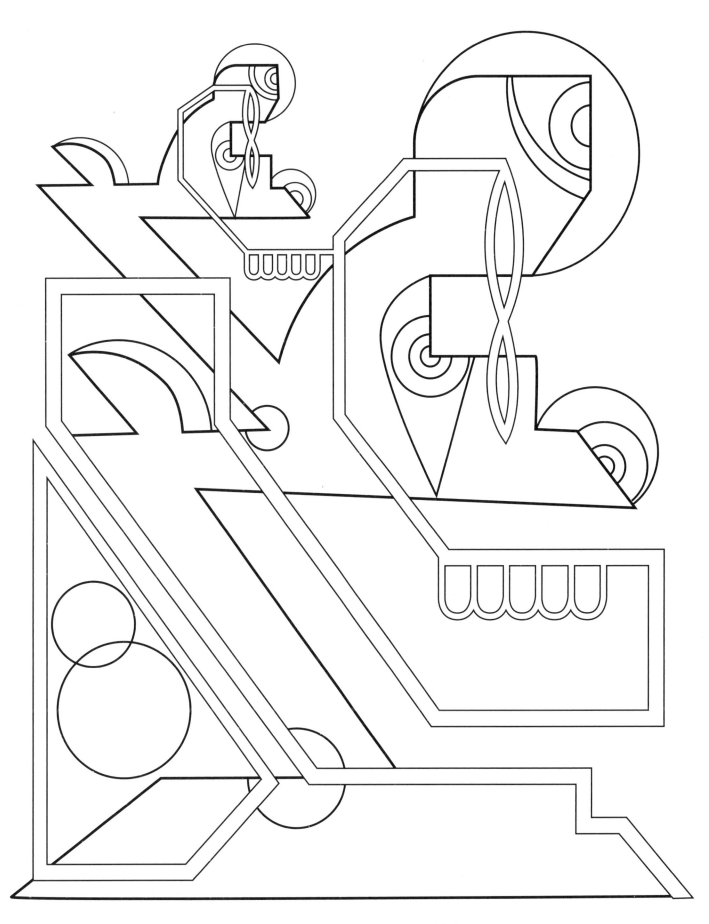

Eamon Ore-Giron · *Branches* · 2012

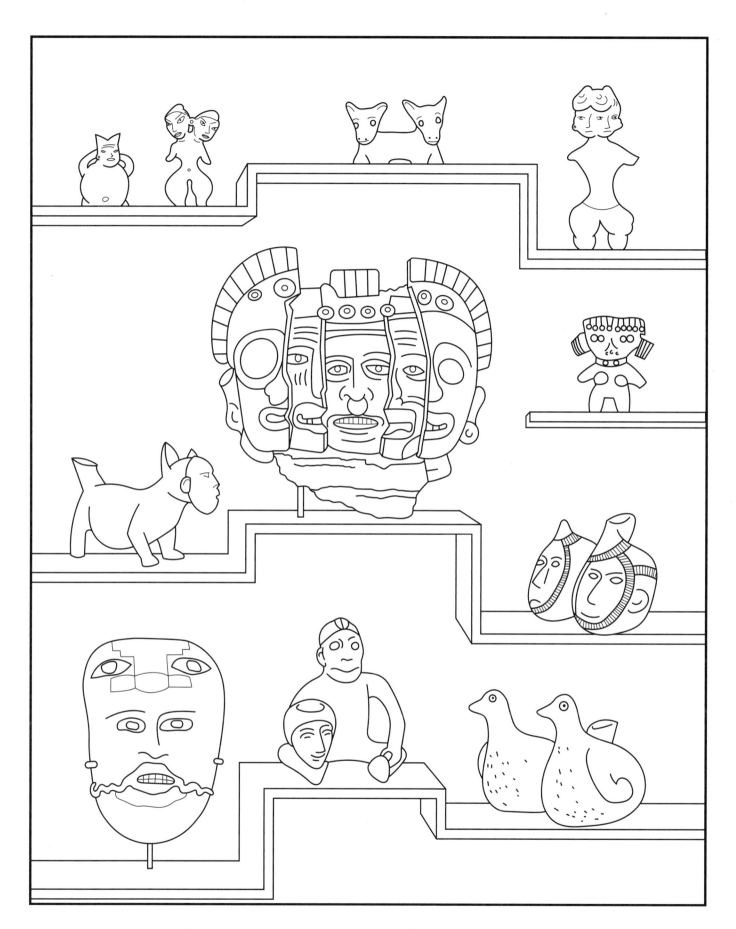

Gala Porras-Kim · *11 Mesoamerican Multiple Perspectives* · 2019

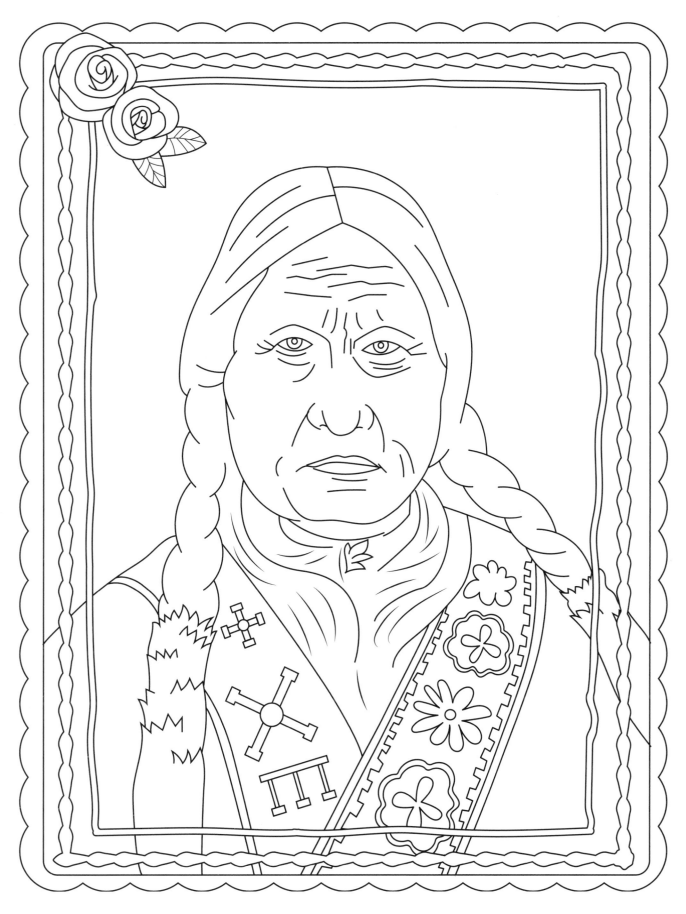

Patrick Martinez · *Sitting Bull Cake* · 2019

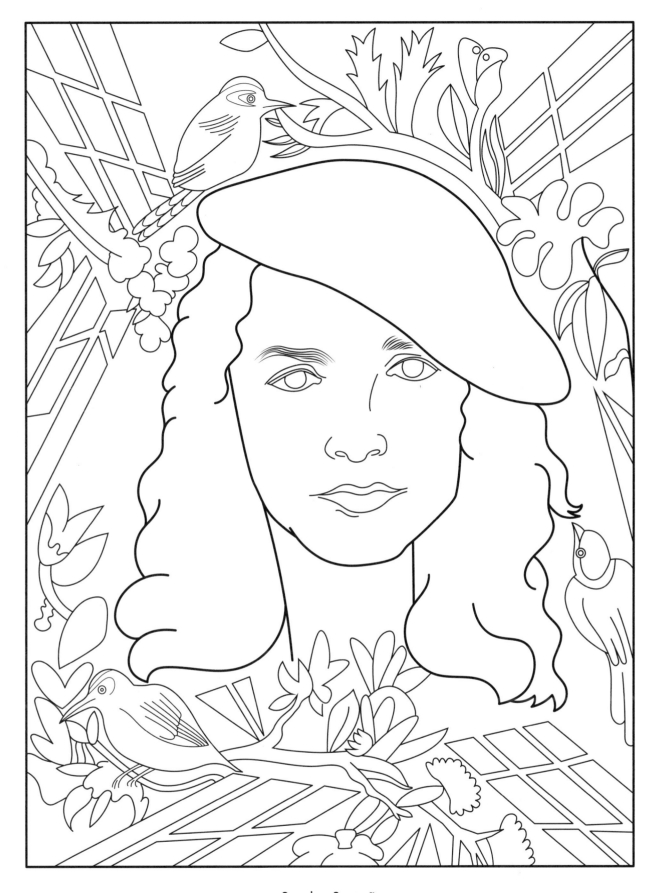

Carolyn Castaño

Other Feminist Histories: Tamara Bunke Bider aka Tania la Guerrillera · 2015

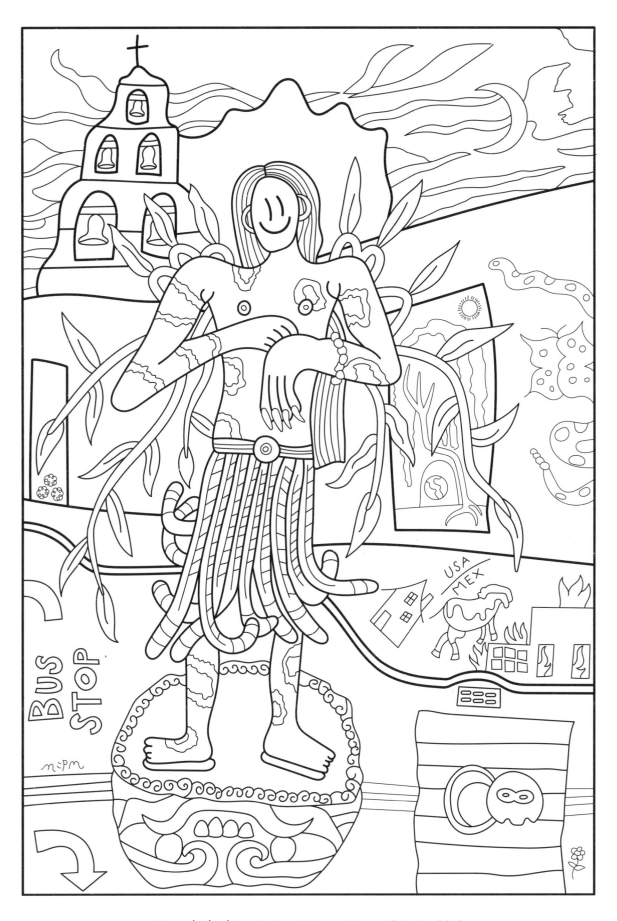

Marcel Alcalá · *In the Midst of Inner Spirit* · 2019

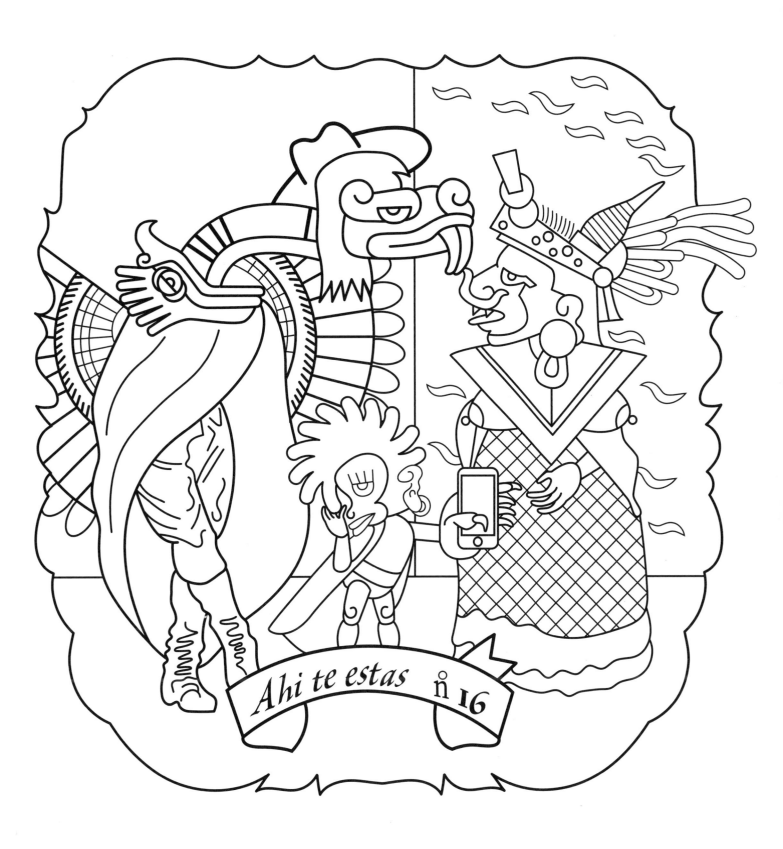

Michael Menchaca
Ahi Te Estas No. 16 from La Raza Cósmica 20XX · 2019

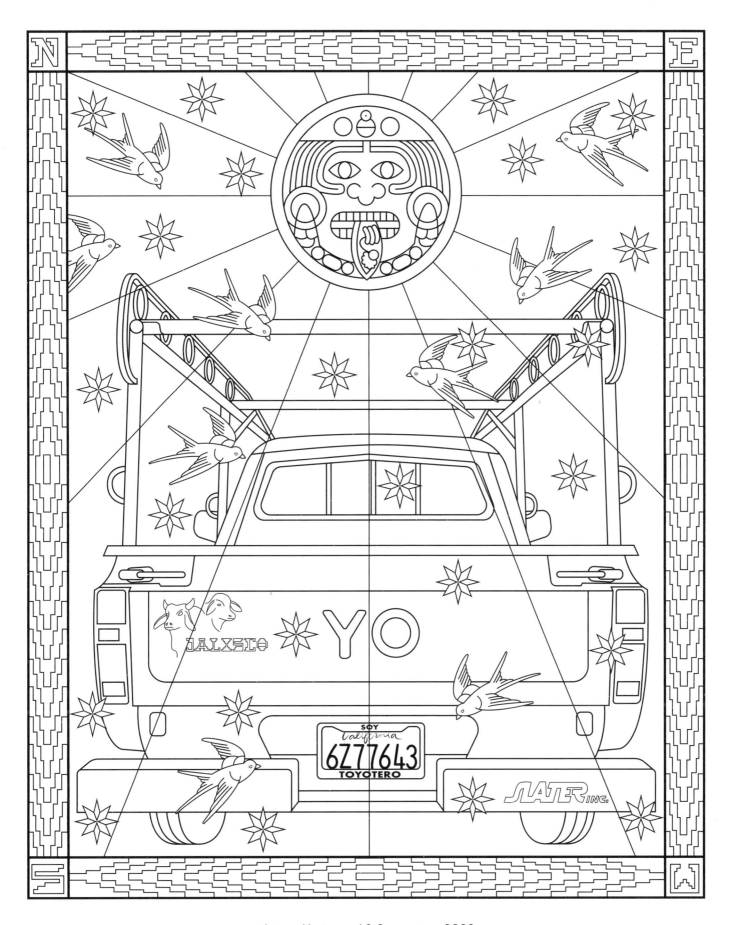

Jaime Muñoz · *LA Commute* · 2020

ARTIST BIOGRAPHIES

Marcel Alcalá
@marcel_alcala
marcelalcala.com

Marcel Alcalá is a queer Chicanx artist originally from Santa Ana, California, now based in Los Angeles. Their artistic practice includes performance, video, sculpture, drawing, and painting. Their body of work provides a bright and wry take on identity and iconography, incorporating themes of gender, sexuality, class, and urban life.

Felipe Baeza
@felipebaeza
felipebaeza.com

Born in Guanajuato, Mexico, the artist Felipe Baeza lives and works in Brooklyn, New York. Baeza's practice is equal parts confrontation of violent pasts and a tribute to people whose sense of personhood is litigated and defined by those in power. His "fugitive bodies" appear in different states of becoming and at times are abstracted even to the point of invisibility. He received his BFA from the Cooper Union for the Advancement of Science and Art, New York, and his MFA from Yale University.

Carolyn Castaño
@carolyn_castano_studio
carolyncastano.com

Carolyn Castaño is a Colombian American artist based in Los Angeles. Her work explores concepts of iconography and exoticism across a variety of subjects, from tropical plants and birds to important Latin American social and political figures. She received her MFA from the School of the Arts and Architecture at the University of California, Los Angeles, and is currently Assistant Professor of Drawing and Painting at Long Beach City College.

Patrick Martinez
@patrick_martinez_studio

Patrick Martinez maintains a diverse practice that includes mixed-media landscape paintings, neon sign pieces, cake paintings, and his *Pee Chee* series of appropriative works. In this book, we feature two of Martinez's cake paintings, which memorialize leaders, activists, and thinkers in American social and

cultural movements. His work has been exhibited domestically and internationally in Los Angeles, Mexico City, San Francisco, Minneapolis, Miami, New York, Seoul, and The Netherlands. He earned his BFA with honors from the Art Center College of Design in Pasadena, California.

Michael Menchaca
michaelmenchaca.com
#MichaelMenchaca

Michael Menchaca is a multidisciplinary artist working in printmaking, painting, installation, and design. His images reference the visual frameworks of ancient Mesoamerican codices and the attention-seeking user interfaces of video games and new media. His work is allegorical, providing commentary on issues of social and economic inequality, racial prejudice, class discrimination, and digital surveillance. He received his BFA from Texas State University and his MFA from the Rhode Island School of Design.

Ms. Yellow (Nuria Ortiz)
@msyellowart

Ms. Yellow (Nuria Ortiz) is a Mexican American muralist and teaching artist based in Los Angeles. Her work centers on such themes as culture, community, sisterhood, and social justice, and incorporates visual themes and inspiration from the Mexican Muralism movement and the *ukiyo-e* style of Japanese art.

Jaime Muñoz
@flan_jm
jaimemunoz1.com

Jaime Muñoz was born in Los Angeles, and now lives and works in Pomona, California. Juxtaposing imagery drawn from the indigenous art of Mexico and the American Southwest with the mundane objects and landscapes of everyday life, his paintings, sculptures, and installations explore aspects of identity, labor, religion, and the intergenerational harm wrought by colonialism. He received his BA in fine art from the University of California, Los Angeles.

Eamon Ore-Giron
eamonoregiron.com

Eamon Ore-Giron blends a wide range of visual styles and influences in his brightly colored abstract geometric paintings. Referencing indigenous and craft traditions as well as twentieth-century avant-garde art, his paintings move between temporalities and resonate across cultural contexts. Ore-Giron received his BFA from the San Francisco Art Institute and his MFA from the University of California, Los Angeles. He lives and works in Los Angeles.

Gala Porras-Kim
@itsgala

Gala Porras-Kim is a contemporary interdisciplinary artist. Her paintings, drawings, sculptures, and installations explore the artwork of indigenous cultures, concepts of cultural appropriation, and aspects of materiality. Born in Bogotá, Colombia, Porras-Kim now lives and works in Los Angeles. She completed her MFA at the California Institute of the Arts, and holds an MA in Latin American studies from the University of California, Los Angeles.

Sandy Rodriguez
@studiosandyrodriguez
studiosandyrodriguez.com

Sandy Rodriguez was raised on the border between California and Mexico, and is now based in Los Angeles. Rodriguez's work investigates the methods and materials of painting across cultures and histories. Her paintings and codices bridge history, social memory, contemporary politics, and cultural production. She earned her BFA from the California Institute of the Arts.

Carlos Rosales-Silva
@loloafterdark
carlosrosalessilva.com

Carlos Rosales-Silva is an artist and educator working and living between New York and Texas. Grounded in the practice of painting, his multimedia works borrow from sculptural and installation practices. His artistic process considers the histories of the vernacular cultures of the American Southwest, the Western canon of art history, and the political and cultural connections

and disparities between them. He received his BFA from the University of Texas at Austin and his MFA in fine arts from the School of Visual Arts in New York.

Ana Serrano
@anaserrano_o
anaserrano.com

Ana Serrano was born in Los Angeles, and now lives and works in Portland, Oregon. A first-generation Mexican American, she is inspired by the intersection of her dual cultural identities. She is best known for creating work that references the built environment in brightly colored cardboard and paper. She earned her BFA with honors from the Art Center College of Design in Pasadena, California.

Patssi Valdez
@patssi.valdez
patssivaldez.com

Patssi Valdez is a multimedia artist and the co-founder of the seminal collective Asco. Her visual art practice includes photography, painting, paper fashion, and installation. Her work has contributed to a Chicana feminist critique of the socioeconomic and sociopolitical reality of the Chicano community living in the United States. Her artwork is included in major collections, including the Smithsonian American Art Museum, Washington, D.C.; the Whitney Museum of American Art, New York; the Tucson Museum of Art, Arizona; the San José Museum of Art, California; and the El Paso Museum of Art, Texas. Valdez continues making art in her Los Angeles studio.

LIST OF WORKS

Dimensions indicate height followed by width followed by depth.

p. 5
Carolyn Castaño
Other Feminist Histories: Violetta Parra, 2015
Duratrans light box
36¼ x 27½ x 4½ in. (92.1 x 69.9 x 11.4 cm)
Courtesy of the artist

p. 7
Ana Serrano
Cartonlandia, 2008
Cardboard, paper, inkjet prints, acrylic, and balsa wood
64 x 64 x 62 in. (162.6 x 162.6 x 157.5 cm)
Courtesy of the artist, © Ana Serrano
Photo: Julie Klima

p. 9
Eamon Ore-Giron
Talking Shit with Coatlicue, 2017
Flashe on linen
80 x 65 in. (203.2 x 165.1 cm)
Courtesy of the artist
Photo: Cary Whittier

p. 11
Gala Porras-Kim
13 International Dogs, 2019
Graphite, color pencil, and ink on paper mounted on canvas
60 x 48 in. (152.4 x 121.9 cm)
Collection of the Brooklyn Museum
Courtesy of the artist; Commonwealth and Council, Los Angeles

p. 13
Jaime Muñoz
Hands for Hire, 2018
Acrylic and glitter on panel
60 x 48 in. (152.4 x 121.9 cm)
Courtesy of the artist

p. 15
Marcel Alcalá
Amor Eterno, 2019
Pastel on paper
47¾ x 33½ in. (121.3 x 85.1 cm)
Courtesy of the artist and Mickey Gallery

p. 17
Michael Menchaca
Toro Lo Que Quieras Es Tuyo, 2013
Screenprint
25 x 18 in. (63.5 x 45.7 cm)
Courtesy of the artist

p. 19
Ms. Yellow (Nuria Ortiz)
Spirit of my Ancestors, 2018
Spray paint
132 x 108 in. (335.3 cm x 274.3 cm)
Miami, Florida
© Ms. Yellow (Nuria Ortiz)

pp. 20-21
Patrick Martinez
America's Pie, 2018
Heavy body acrylic, acrylic, airbrush, and ceramic cake roses on panel with gold mirror plex
20 x 26 x 3 in. (50.8 x 66 x 7.6 cm)
+ 2 cake pieces, each 7 x 7 x 3 in. (17.8 x 17.8 x 7.6 cm)
Courtesy of Patrick Martinez and Charlie James Gallery

p. 23
Patssi Valdez
Milagros, 2016
Acrylic on canvas
60 x 36 in. (152.4 x 91.4 cm)
Courtesy of the artist

p. 25
Sandy Rodriguez
"Processing Quiltic," detail from *Mapa de la Región Fronteriza de Alta y Baja Califas*, 2017
Hand-processed organic and pigment watercolor on amate paper
JPMorgan Chase Art Collection
Photo: J6 Creative

p. 26
Ana Serrano
Neveria, 2012
Cardboard, paper, inkjet prints, and acrylic
13 x 13 x 12½ in. (33 x 33 x 31.8 cm)
Courtesy of the artist, © Ana Serrano
Photo: Julie Klima

p. 27
Ana Serrano
Iglesia La Luz del Mundo, 2012
Cardboard, paper, inkjet prints, and acrylic
10½ x 13½ x 10½ in. (26.7 x 34.3 x 26.7 cm)
Courtesy of the artist, © Ana Serrano
Photo: Julie Klima

p. 29
Carolyn Castaño
Tropical Geometries: Ruana Interruption (Red and Gold), 2017
Watercolor, gouache, and acrylic on paper mounted on Plexiglas
50½ x 38½ in. (128.3 x 97.8 cm)
Courtesy of the artist

p. 30
Carlos Rosales-Silva
Yeyi Coatl, 2019
Crushed stone and acrylic on panel
16 x 12 in. (40.6 x 30.5 cm)
Courtesy of Carlos Rosales-Silva and Ruiz-Healy Art

p. 31
Carlos Rosales-Silva
Chupando Tamarindo, 2019
Crushed stone and acrylic on panel
30 x 24 in. (76.2 x 61 cm)
Courtesy of Carlos Rosales-Silva and Ruiz-Healy Art

p. 33
Sandy Rodriguez
Nopal-Opuntia basilaris from the Codex Rodriguez-Mondragón, 2017
Hand-processed organic and pigment watercolor on amate paper
22¾ x 15¼ in. (57.8 x 38.7 cm)
JPMorgan Chase Art Collection
Photo: J6 Creative

p. 35
Felipe Baeza
Moving through the flesh to elsewhere, 2019
Ink, graphite, acrylic, flashe, cut paper, interference powder, and varnish on panel
14 x 11 in. (35.6 x 27.9 cm)
© Felipe Baeza, courtesy Maureen Paley, London

p. 37
Michael Menchaca
Calpamulato No. 13 from La Raza Cósmica 20XX, 2019
Screenprint
22½ x 21 in. (57.2 x 53.3 cm)
Courtesy of the artist

p. 39
Ms. Yellow (Nuria Ortiz)
Resilient, 2021
Spray paint
264 x 216 in. (670.6 x 548.6 cm)
Del Amo Swapmeet, Compton, California
© Ms. Yellow (Nuria Ortiz)

p. 41
Jaime Muñoz
Impossible Dreams, 2018
Acrylic, glitter, and texture paste on panel
60 x 48 in. (152.4 x 121.9 cm)
Courtesy of the artist

p. 43
Patssi Valdez
The Hummingbird Queen, 2017
Acrylic on canvas
48 x 36 in. (121.9 x 91.4 cm)
From the Collection of Alfred Fraijo Jr. and Arturo Becerra-Fraijo

p. 45
Marcel Alcalá
Lucy, 2020
Oil on panel
48 x 36 in. (121.9 x 91.4 cm)
Courtesy of the artist and Night Gallery

p. 47
Felipe Baeza
Tanto refugio como advertencia a la vez, 2019
Ink, graphite, acrylic, flashe, cut paper, and varnish on panel
11 x 14 in. (27.9 x 35.6 cm)
© Felipe Baeza, courtesy Maureen Paley, London

p. 49
Eamon Ore-Giron
Branches, 2012
Flashe on linen
12 x 10 in. (30.5 x 25.4 cm)
Courtesy of the artist

p. 51
Gala Porras-Kim
11 Mesoamerican Multiple Perspectives, 2019
Graphite, color pencil, and ink on paper mounted on canvas, mahogany artist's frame
60 x 48 in. (152.4 x 121.9 cm)
Private collection
Courtesy of the artist; Commonwealth and Council, Los Angeles

p. 53
Patrick Martinez
Sitting Bull Cake, 2019
Heavy body acrylic, acrylic, airbrush, and ceramic cake roses on panel with gold mirror plex
26 x 20 x 3 in. (66 x 50.8 x 7.6 cm)
Courtesy of Patrick Martinez and Charlie James Gallery

p. 55
Carolyn Castaño
Other Feminist Histories: Tamara Bunke Bider aka Tania la Guerrillera, 2015
Duratrans light box
36¼ x 27½ x 4½ in. (92.1 x 69.9 x 11.4 cm)
Courtesy of the artist

p. 57
Marcel Alcalá
In the Midst of Inner Spirit, 2019
Pastel on paper
47¾ x 33½ in. (121.3 x 85.1 cm)
Courtesy of the artist and Mickey Gallery

p. 59
Michael Menchaca
Ahi Te Estas No. 16 from La Raza Cósmica 20XX, 2019
Screenprint
22½ x 21 in. (57.2 x 53.3 cm)
Courtesy of the artist

p. 61
Jaime Muñoz
LA Commute, 2020
Acrylic, airbrush, glitter, and flocking on panel
60 x 48 in. (152.4 x 121.9 cm)
Courtesy of the artist

First published 2021 by Merrell
Publishers, London and New York

Merrell Publishers Limited
70 Cowcross Street
London EC1M 6EJ
merrellpublishers.com

in association with

Vilcek Foundation
21 East 70th Street
New York, NY 10021
vilcek.org

Text and drawings copyright © 2021
Vilcek Foundation
All other illustrations copyright
© 2021 the copyright holders; see
p. 63. Photograph of colored pencils
on cover: © iStock.com/worldofstock
Design and layout copyright © 2021
Merrell Publishers Limited

A catalogue record for this book is
available from the Library of Congress.

British Library Cataloguing in
Publication Data. A catalogue record
for this book is available from the
British Library.

ISBN 978-1-8589-4699-3

Produced by Merrell Publishers Limited
Printed and bound in China

Front cover
Top: Felipe Baeza, *Moving through the
flesh to elsewhere* (detail), 2019; see
p. 35.
Bottom left: Michael Menchaca,
*Calpamulato No. 13 from La Raza
Cósmica 20XX* (detail), 2019; see p. 37.
Bottom right: Patssi Valdez, *Milagros*
(details), 2016; see p. 23.

Back cover
Left: Ana Serrano, *Cartonlandia*, 2008;
see p. 7.
Right: Eamon Ore-Giron, *Talking Shit
with Coatlicue*, 2017; see p. 9.

Page 2, left: Michael Menchaca,
*Calpamulato No. 13 from La Raza
Cósmica 20XX* (detail), 2019; see p. 37.
Pages 2, right, and 3, left: Jaime Muñoz,
LA Commute (details), 2020; see p. 61.
Page 3, right: Jaime Muñoz, *Hands for
Hire* (detail), 2018; see p. 13.

RITA GONZALEZ is the Terri and Michael
Smooke Curator and Department Head
of Contemporary Art at the Los Angeles
County Museum of Art.

PAULA KINSEL is an artist, graphic
designer, and art director.